FANTASTIC FUNGI

THE COLORING BOOK

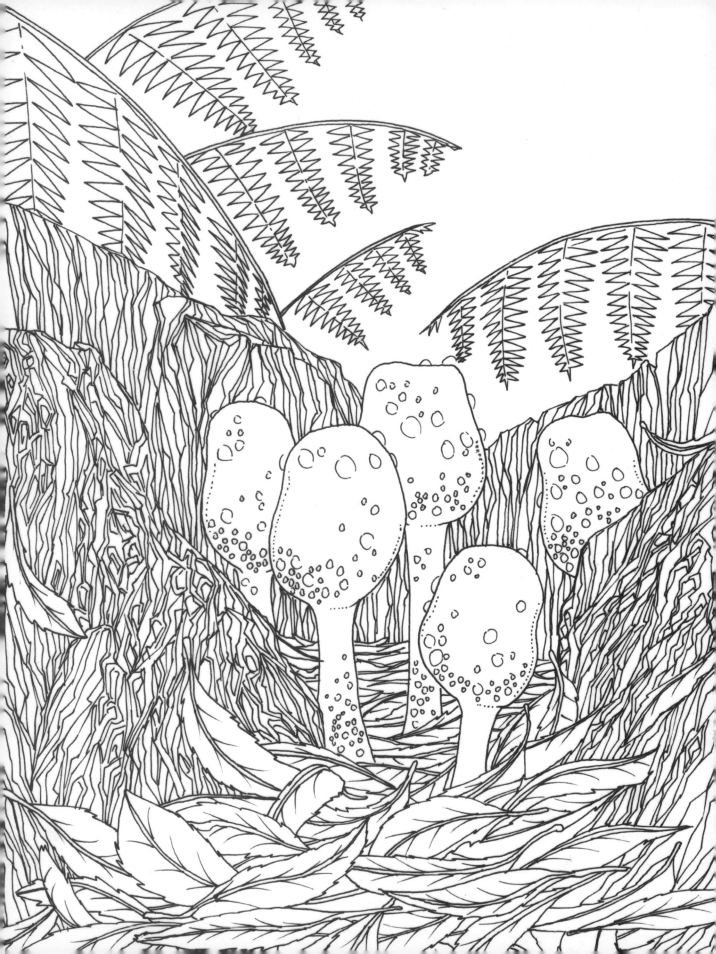

FANTASTIC FUNGI
THE COLORING BOOK

ILLUSTRATED BY
Rohan Daniel Eason

TEXT BY MATTHEW GILBERT
PHOTOGRAPHS BY TK

EARTH AWARE

SAN RAFAEL • LOS ANGELES • LONDON

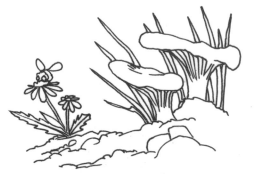

Neither plant nor animal, fungi exist as part of a vast myce-lial network that lies just beneath the Earth's surface. We see mere glimpses of their existence through the flow-ering mushrooms that shoot up in an exotic array of reds, yellows, blues, purples, and greens before disappearing almost as quickly as they appeared.

Fungi are mostly water and fiber like plants, and are repro-ductive organs like fruits, but evolutionarily speaking, they are closer to us on the tree of life. Scientists and researchers around the world, trained in universities and inspired by their passion for the planet, are discovering that underground networks of inter-connected organisms are revealing a new story about the planet's ability to heal itself. The innate intelligence of these networks—the result of billions of years of evolution—has much to teach us.

In this unique coloring book, create your own versions of these enigmatic organisms with seventy original coloring pages. Introductory notes from mycological experts featured in the acclaimed documentary film and book of the same name, *Fantastic Fungi*, illuminate fascinating details about the amazing world of fungi, and eight pages of color photos offer further coloring inspiration.

The "third kingdom" of fungi and mushrooms is a realm of mystery on whose secrets the future of life on Earth may depend. At a time when solutions to our planet's most pressing challenges seem as elusive as ever, the ground beneath our feet may hold the most promising answers.

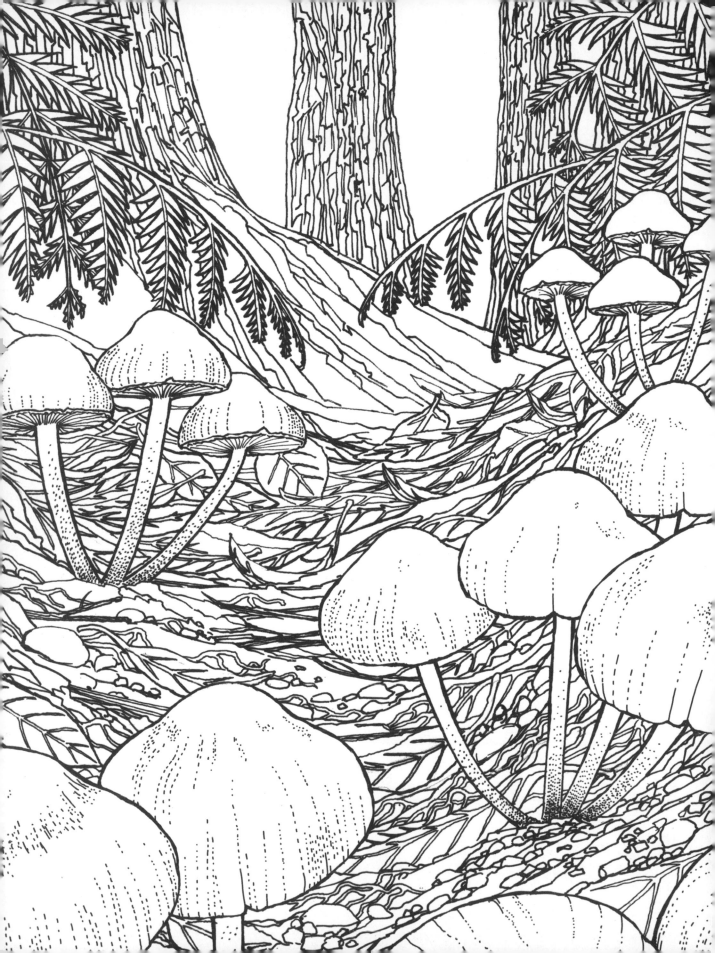

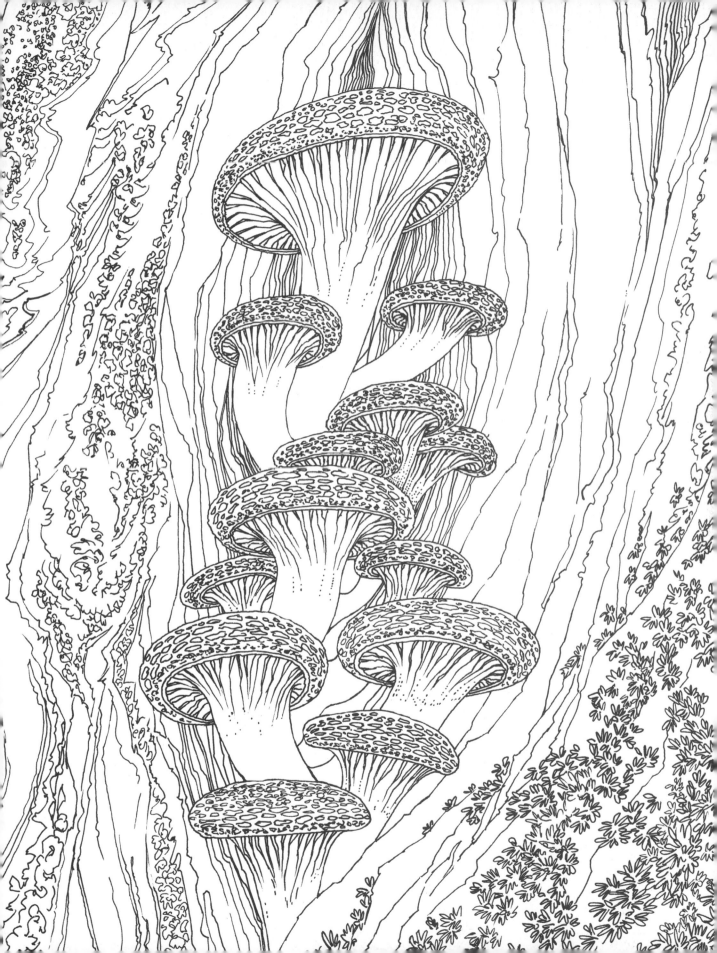

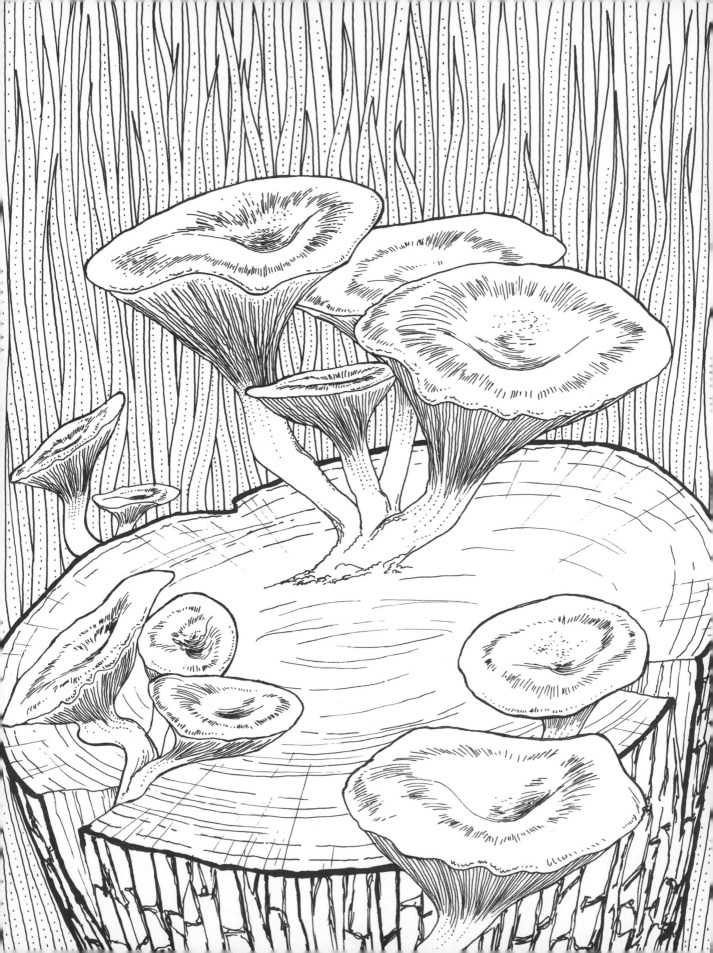

What goes on beneath a forest floor is just as interesting—and just as important—as what goes on above it. A vibrant network of nearly microscopic threads is recycling air, soil, and water in a continuous cycle of balance and replenishment. Survival depends not on the fittest, but on the collective.

Imagine a log that was once a tree. Maybe it died of old age or became infected by a disease and fell over. When it did, fungi spread into the log from the earth below and started decomposing it. These fungi are part of a vast network of underground vegetation called mycelium, composed of very tiny, cobweb-like threads of organic life called hyphae.

In the process of decaying, the wood releases its nutrients. Those nutrients become available to other organisms in the food web, including the fungus, which distributes the nutrients through the mycelium. After many challenges, these networks come to the surface and form mushrooms, the reproductive structures of fungi. . . . When you pick a mushroom, you stand upon a vast, hidden network of fungal mycelium that literally extends underneath every footstep you take. These networks are the foundation of life. They create the soils that nourish all life on land. Without fungi, we do not have soil. Without soil, there is no life.

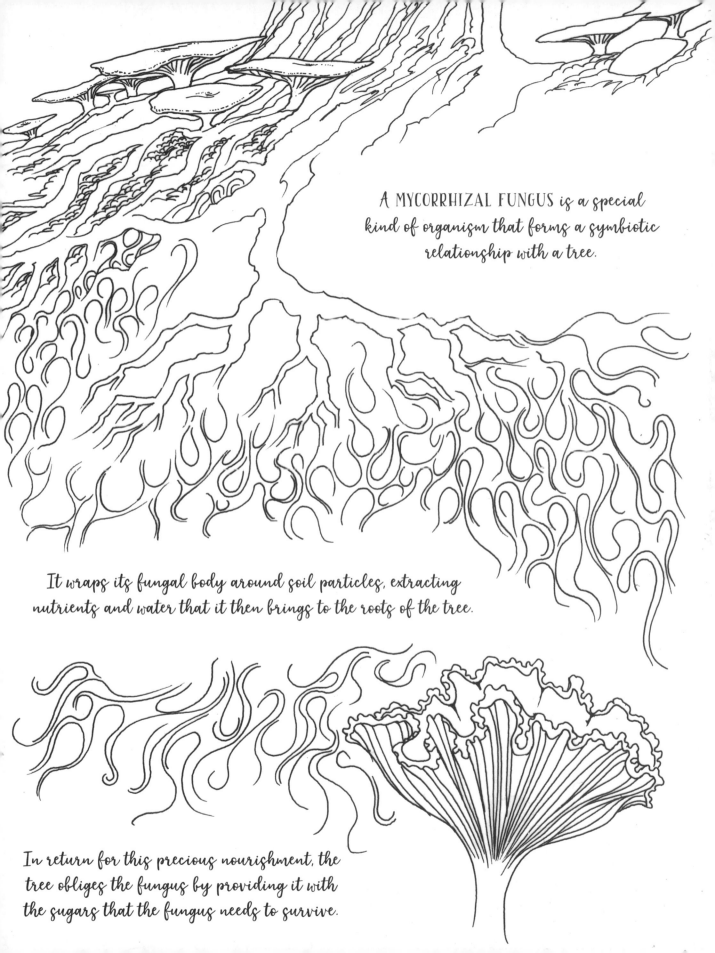

A MYCORRHIZAL FUNGUS is a special kind of organism that forms a symbiotic relationship with a tree.

It wraps its fungal body around soil particles, extracting nutrients and water that it then brings to the roots of the tree.

In return for this precious nourishment, the tree obliges the fungus by providing it with the sugars that the fungus needs to survive.

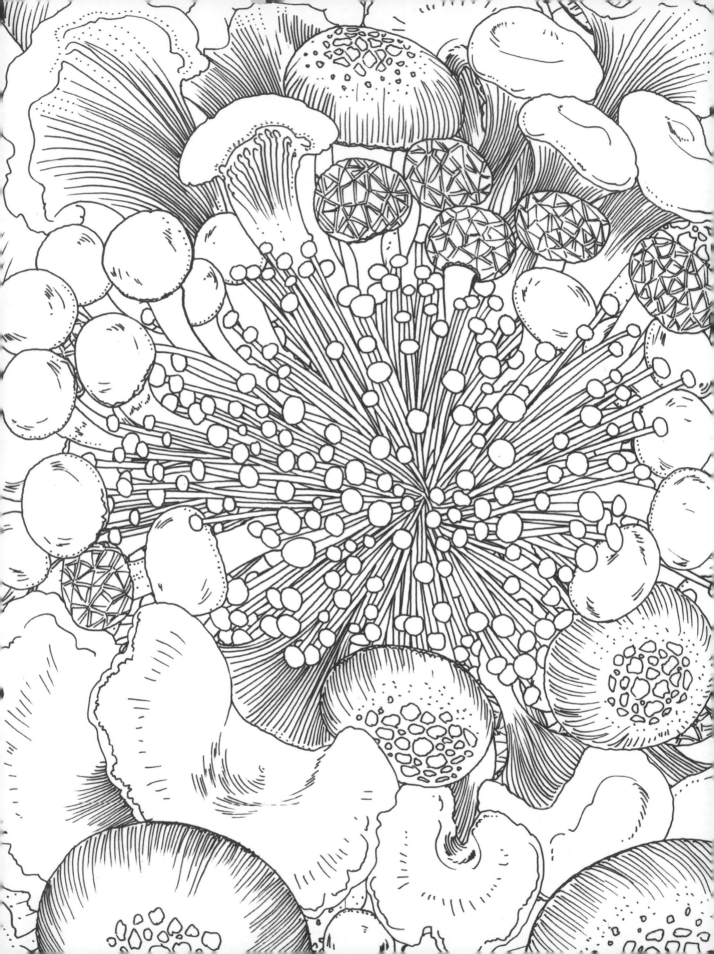

The first mushroom to be cultivated in the United States was the *Agaricus bisporus* (commonly known as the white button mushroom), but we have France to thank for that. During the reign of Louis XIV, French cultivators noticed the mushroom growing on horse manure. They transposed the mycelium underneath it to compost beds, where the mushrooms would grow in controlled abundance. They eventually realized they could dry the mycelium and ship it. That's one of the really interesting things about mycelium: It can dry out and lay dormant for a long time, but as soon as you add water, it wakes up.

There was a problem, though. This dried mycelium was basically a wild product, and it contained all kinds of microbial hitchhikers. When American buyers purchased and cultivated it, other fungi and bacteria would sometimes kill it. This motivated the USDA to figure out how to grow *Agaricus bisporus* from spores, thereby ensuring both the species and the purity of the culture.

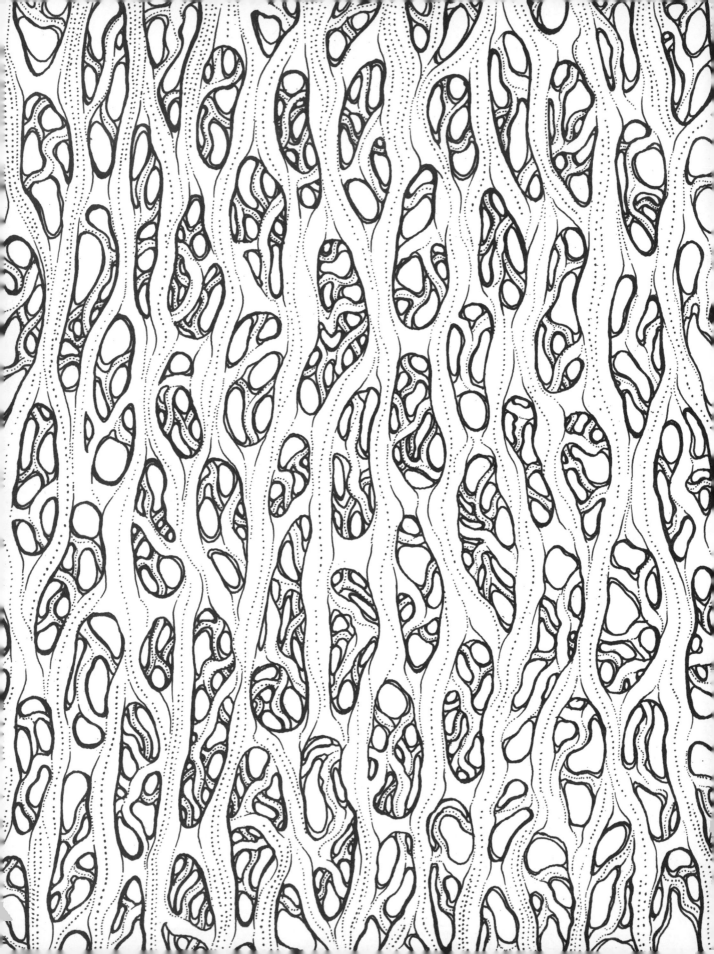

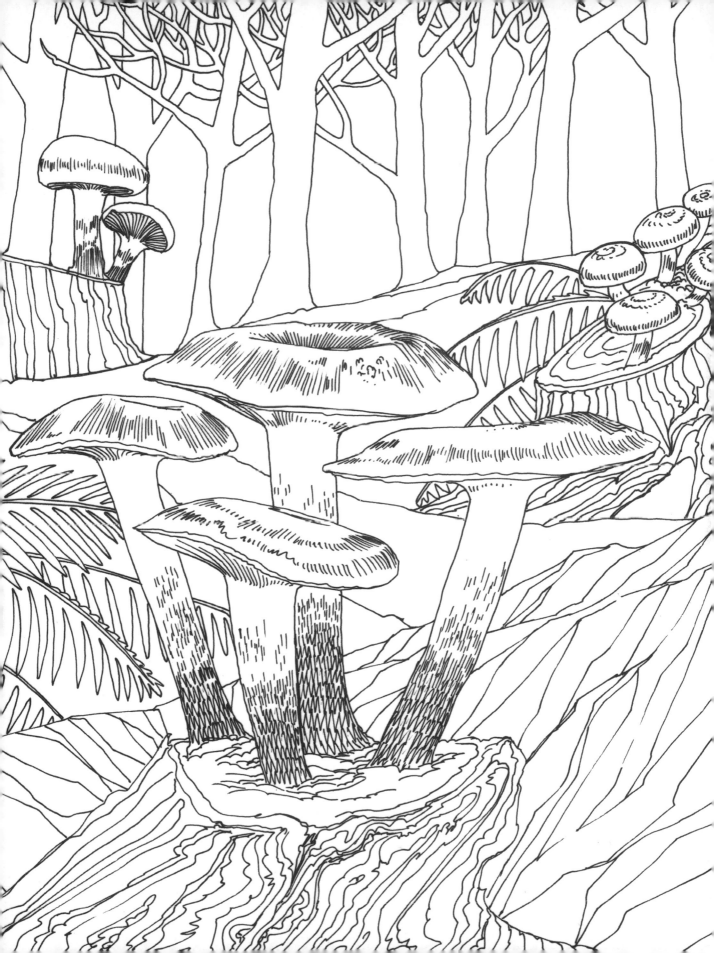

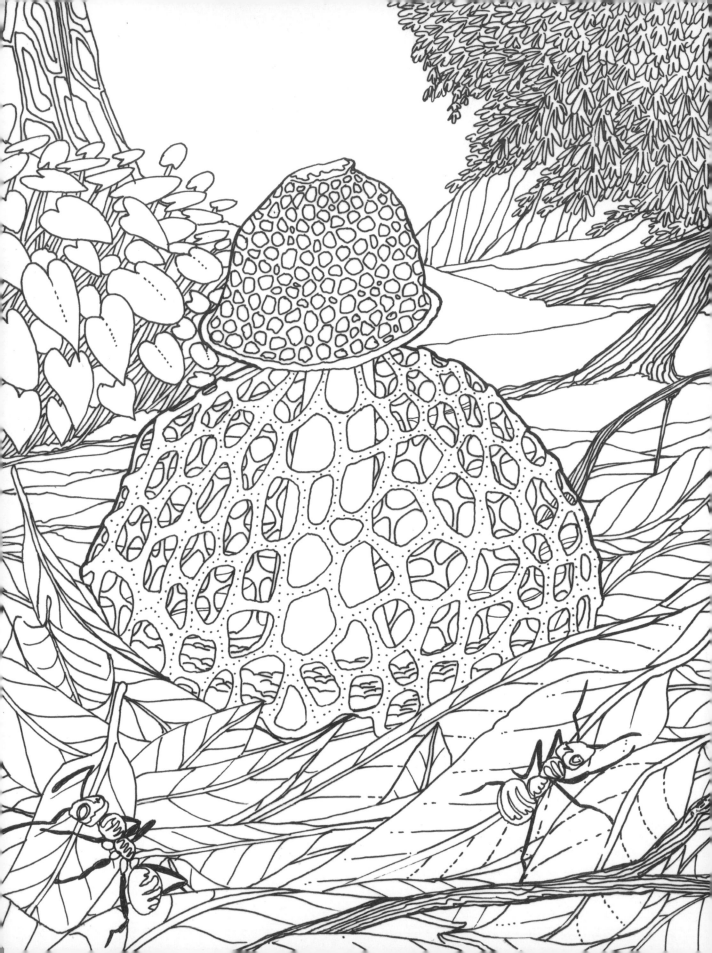

Virtually all white button mushrooms today originate from the same spore called the U1 hybrid, which was discovered by a Dutch scientist named Gerda Fritsche in 1980.

This "superspore" was selected and continues to be preferred because it produces a high yield of disease-resistant mushrooms with good flavor.

One piece of A. BIOSPORUS mycelium, the size of a watch battery and the weight of a housefly, can produce 100,000 pounds of white button mushrooms.

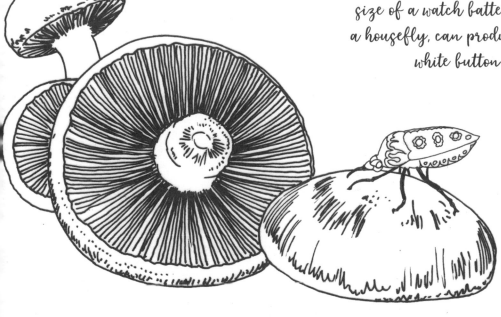

Bees are dying, industry fixes have failed, and food sources worldwide are threatened. Remarkably, one promising solution comes from an unlikely source: mushrooms. . . . Beekeeping in the United States reached a critical juncture in 1987, when the Varroa mite (also as known Varroa destructor) arrived, probably from Europe. It actually has a relatively harmless relationship with the Eastern honeybee (*Apis cerana*), but the Western honeybee (*Apis mellifera*) doesn't have good defenses against it. The Varroa mite feeds on the larvae, or baby honeybees, which spreads and amplifies the viruses it creates—in particular the deformed wing virus (DWV)—and reduces the longevity of the bees. In largely temperate climates, this mite will keep multiplying until a colony dies, usually within two years. Colony loss from the Varroa mite (and other factors such as loss of foraging habitat, pesticides, and other viruses) averaged 40 percent across the United States from 2017 to 2018 and spiked as high as 85 percent in some states.

A couple years ago, I became aware of the work being done by Fungi Perfecti and Paul Stamets. They had been testing some fungal extracts with antiviral properties, and so we began a series of experiments feeding these extracts to bees and had some success. The bees lived longer and their virus levels came down (a thousandfold or more in some instances), perhaps because the extract boosted their immune system, though we're not yet sure how it works. In a second set of experiments tested on five hundred hives in Washington State, we used an entomopathogenic fungus called Metarhizium that's been shown to harm the mite—it basically grows on the mites and kills them, and in certain dosages it doesn't affect the bees.

If the bees were to be lost, it would force radical changes in food costs and food security around the country. I've been working with industry and commercial beekeepers and hobbyists for many years, and they are desperately searching for answers. We think we may have some, and they have the potential to change everything.

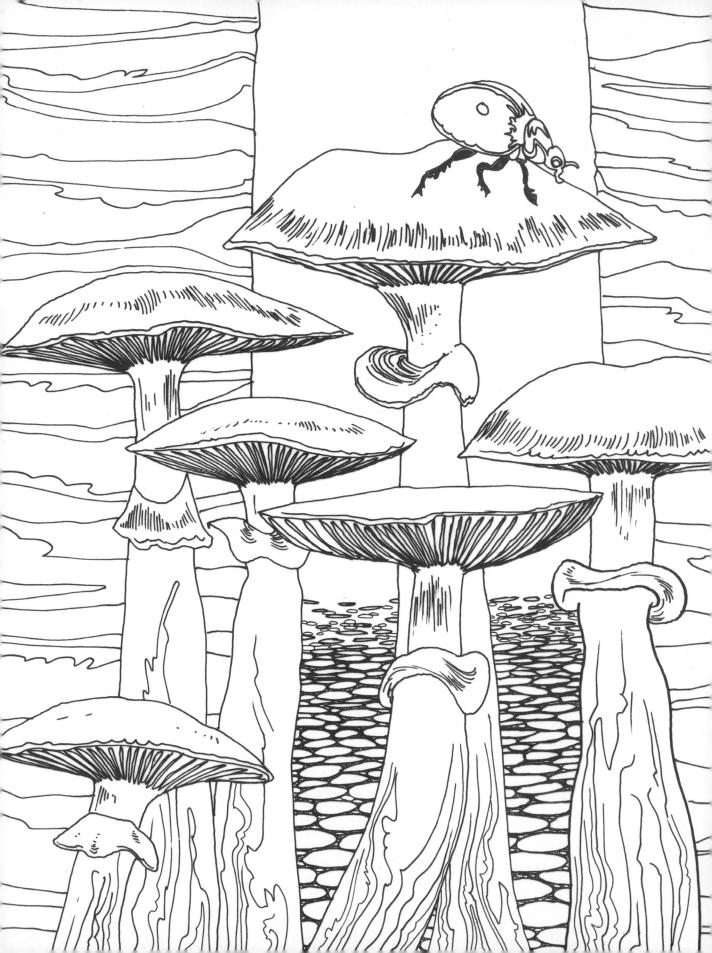

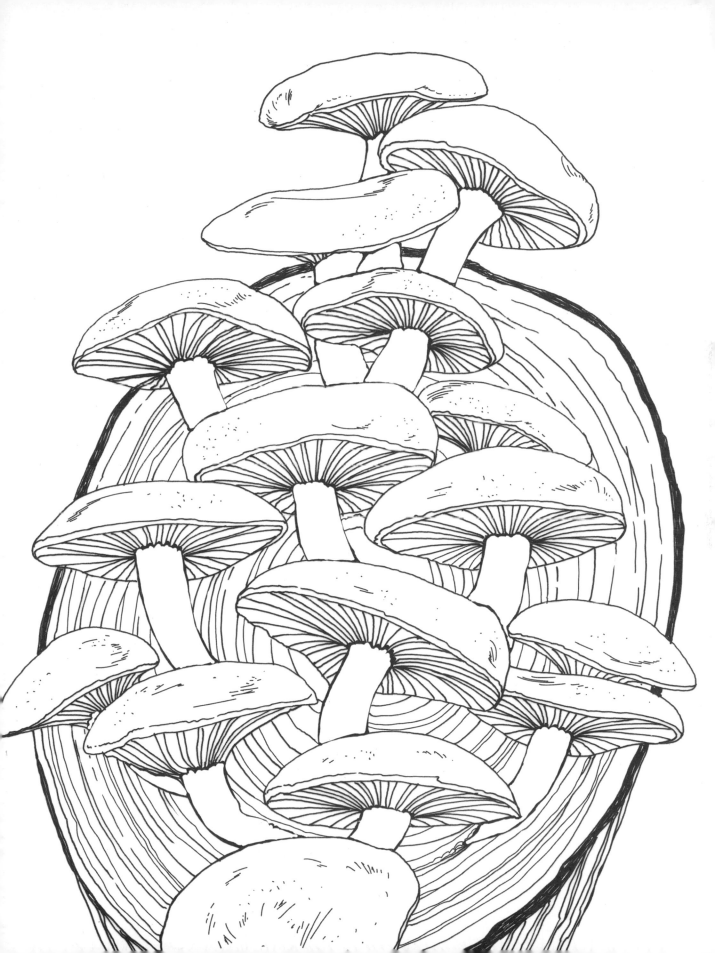

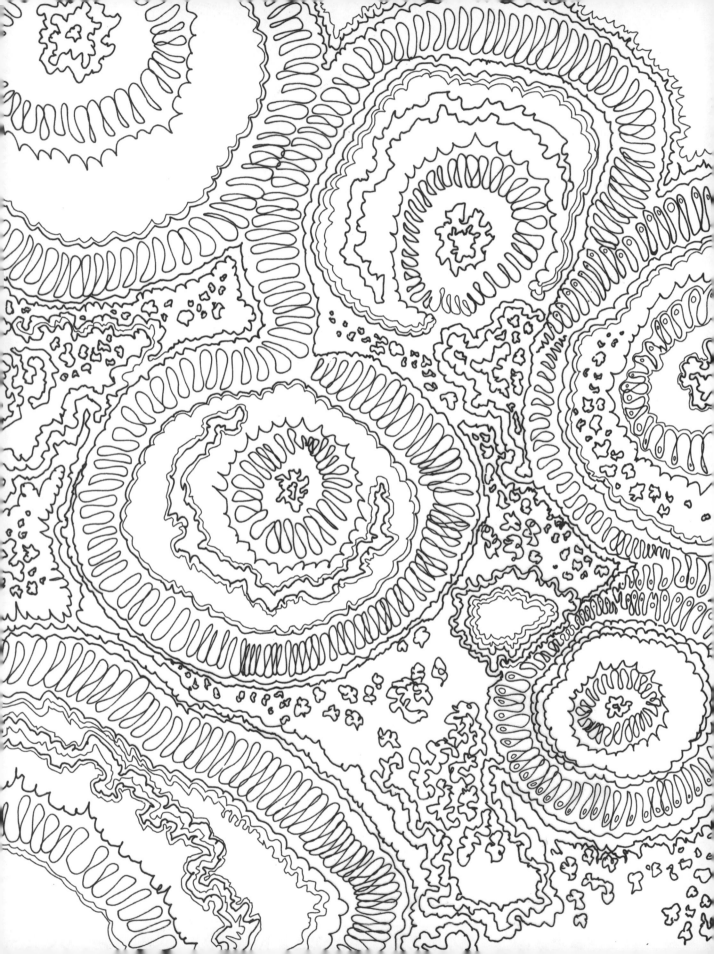

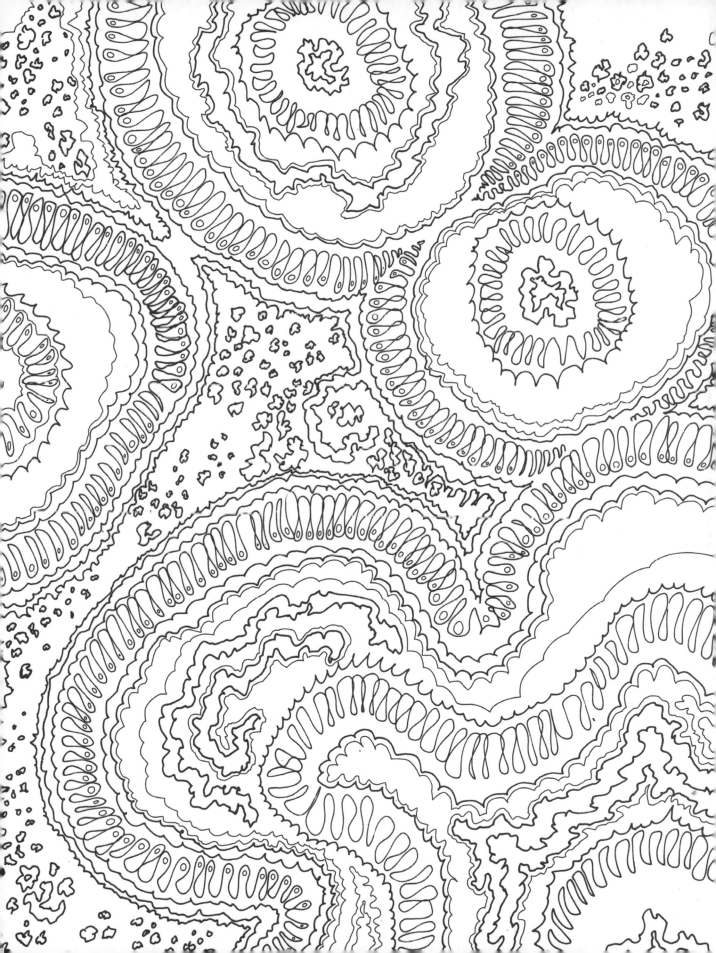

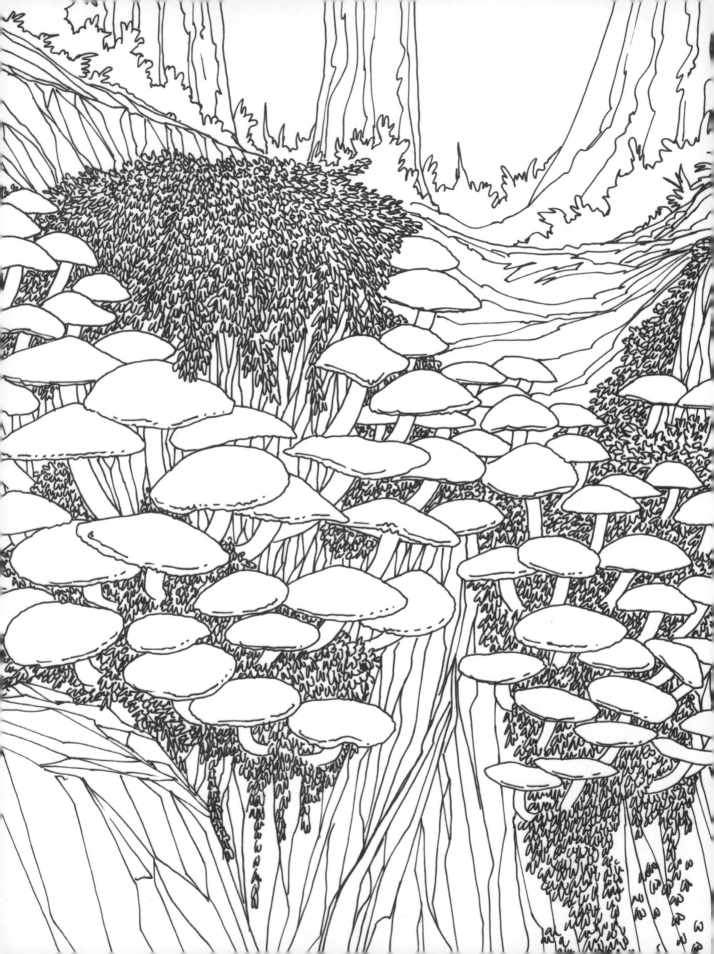

If the bees go, we go. All of the foods we need to stay healthy—including fruits, vegetables, nuts, seeds, berries, and some grains—come from pollinating plants.

Before the appearance of flowers, the Earth was a boring and drab place, mostly green. The cold-blooded herbivorous reptiles roaming the planet needed to eat huge quantities of leaves to stay alive.

Without the evolution of the flower, warm-blooded mammals would never have evolved.

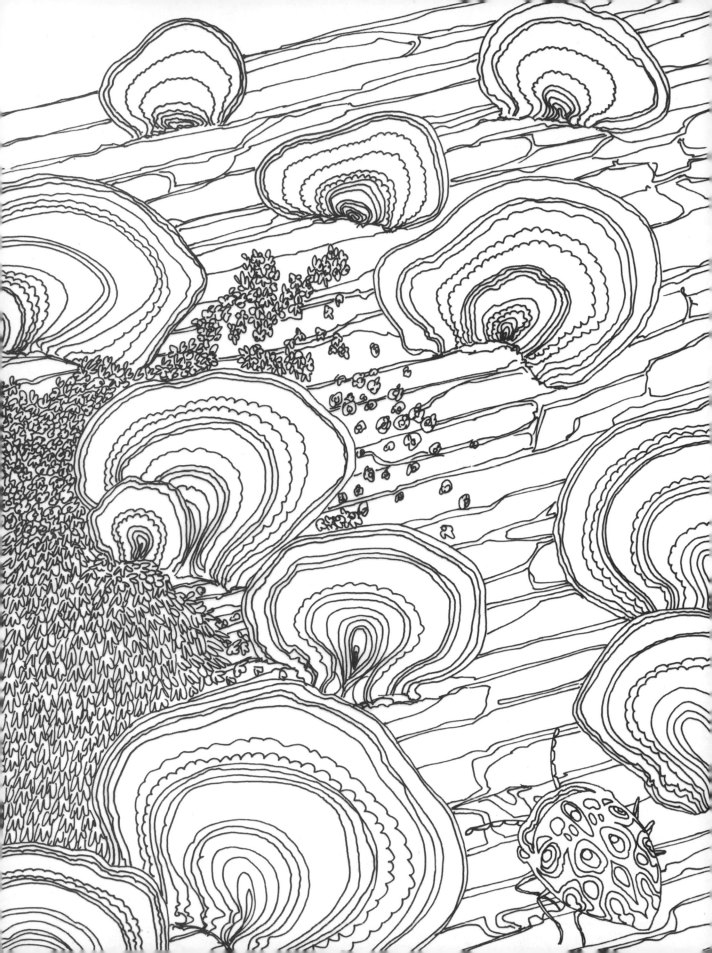

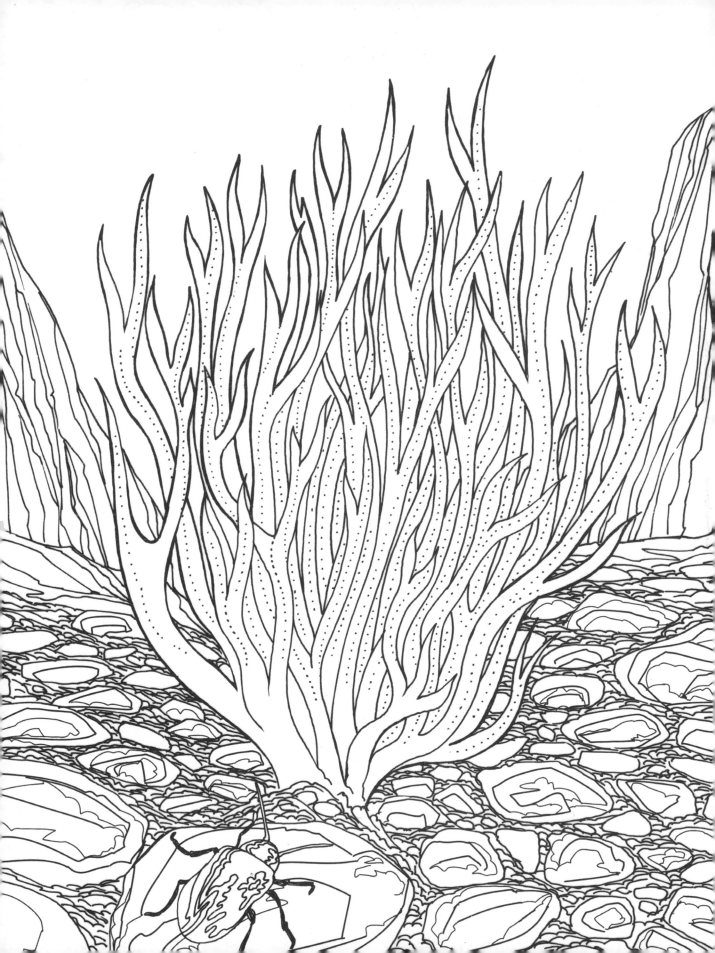

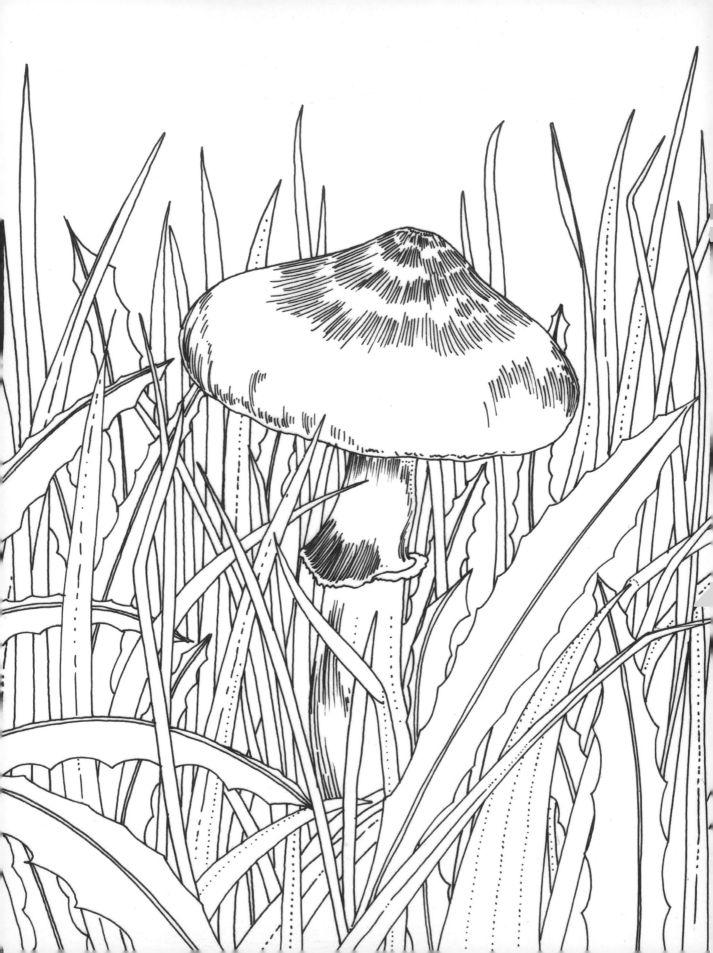

For decades, the Texaco oil company constructed hundreds of unlined earthen waste pits for its oil operations in Ecuador. Out of these pits, toxic waste has continuously leached into rivers and the surrounding environment. Damage to both the land and its people has been extensive. While various groups continue to fight the company in court over repatriation and the cost and responsibility of cleanup, the local people who have been affected by the spill created a nonprofit called the Amazon Mycorenewal Project (now CoRenewal) in 2010 that represents over 150 indigenous communities. With the help of a small team of consultants, they are researching, designing, and implementing biological solutions using the remedial power of fungi. Pilot projects are underway addressing both petroleum-contaminated soils and municipal wastewater contaminants, while the organization continues to study the capacity of native microbes to mitigate petroleum toxicity, with plans for a fungal research laboratory and mushroom-cultivation space.

Fungi builds soil, which expands the carrying capacity of the ecosystem and thus the capacity for adding biodiversity.

The more complex your biodiversity, the larger your cast of characters, the more opportunities for plants and other creatures to collaborate on providing maximum benefit to all.

We need to be engaging fungi purposefully, because they are the agents of sustainability, and they will give us resilience.

Mushrooms can have powerful health benefits. Throughout history, indigenous cultures have used mushrooms as medicine, and as the Western world begins to study mushrooms in earnest, we're learning more and more about their incredible potential. . . .

How important are fungi to medicine? The clearest and best example we have is the discovery of penicillin by Alexander Fleming in 1928. He received the Nobel Prize in 1945 for his work, but there's a lot more to the story.

The penicillin strains produced in Fleming's and others' laboratories at the time weren't productive enough to make them commercially feasible, so the research continued. Around 1942, a lab assistant in Chicago acquired a moldy piece of fruit from the local grocery and isolated the strain that became the first hyperproducer of penicillin. It turns out that different strains of fungi within the same species can express different amounts of active ingredients, which speaks to the importance of mycodiversity. This all happened during World War II, and the discovery was revolutionary because there were no broad-spectrum antibiotics that could help to heal battle wounds. The Allied powers had these powerful antibacterial strains. The Axis powers did not. . . .

It's been suggested that the discovery of this hyperproducing strain of penicillin was so significant, both medically and economically, that it tilted the balance of the war in favor of the Allied powers.

There are as many as 3.8 million species of fungi—many times more than plants.

About twenty thousand of them produce mushrooms, and of those, a small number are seriously poisonous, a slightly larger number (maybe thirty or so) are known to be edible, and a handful of others have powerful health benefits.

Some mushrooms work by producing compounds that act like chemical warfare agents to fight off competitors or intruders such as bacteria, viruses, and other fungi.

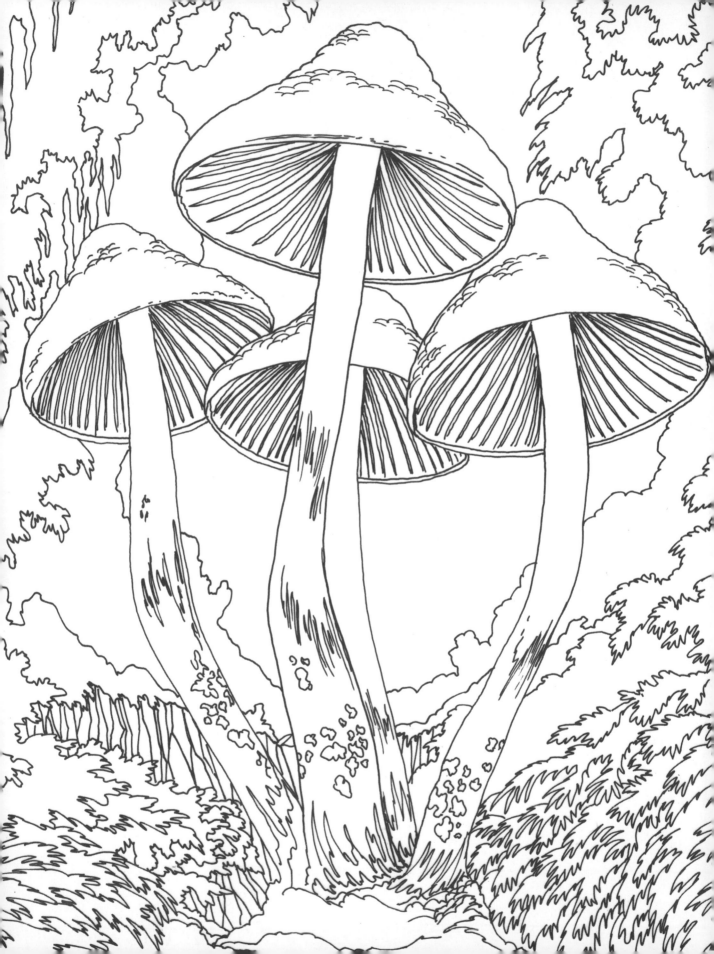

W hile teaching journalism at Berkeley not long ago, I learned about some surprising research involving psilocybin, the active ingredient in so-called magic mushrooms. It was being used to induce mystical experiences as well as treat people who were suffering from end-of-life anxiety and existential distress after learning they'd been diagnosed with terminal cancer.

As I began talking to some of the researchers involved, I learned to my astonishment that the history of this work dates back to the 1950s, and that long before LSD became a drug of the counter-culture, it had been embraced in psychiatric circles. Hundreds of peer-reviewed papers had been published detailing its successful use in treating depression, alcoholism, and obsessive-compulsive disorder (OCD), among other conditions. The doctors I was talking with had begun to excavate this buried knowledge. And buried it was. When these psychoactive substances jumped from the lab to the street in the 1960s, unleashing a kind of Dionysian energy and inspiring a growing counterculture to "question authority," the government came down hard, the research community fell in line, and the work essentially stopped.

This was a wake-up call for me. A highly productive area of scientific research had simply been abandoned, which doesn't hap-pen very often. Now, decades later, it's experiencing a renaissance. There's a growing willingness to let people experiment once again with these powerful molecules to see how useful they might turn out to be.

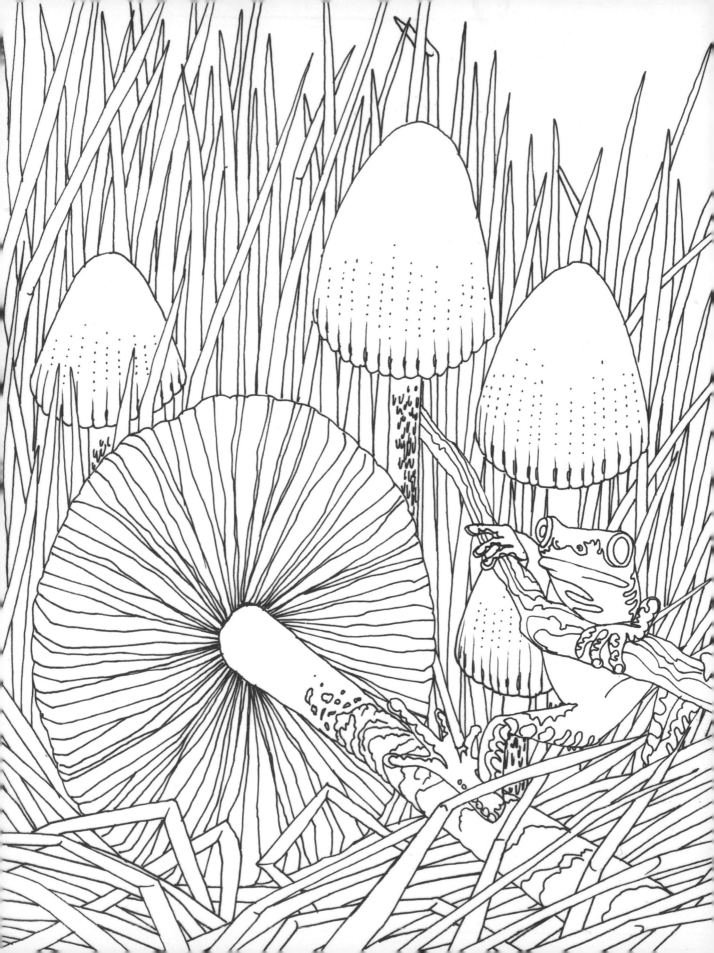

Mushrooms, whether for nutrition, medical benefit, or ecstatic experience, have been used by different cultures throughout the world for thousands of years.

One thing that mushrooms and other psychedelics reliably do is induce synesthesia—the conflated perception of one sensory modality with another, for example "hearing colors" or "seeing music."

. . . [psychoactive] experiences [are often] characterized by a sense of the interconnectedness of all persons and things, sacredness, and an authoritative sense that the experience was more real and true than everyday waking consciousness.

The story of fungi is the story of our essential unity. The more we understand and respect this third kingdom, the more solutions we'll uncover for the many challenges that face us.

It's not surprising that we are latecomers to the discovery of the usefulness of mushrooms, because our encounters with them are very short; they pop up suddenly, and then they're gone. This is what fungi and mycelium bring to the table: They represent ecological remedies that literally lie beneath our every footstep.

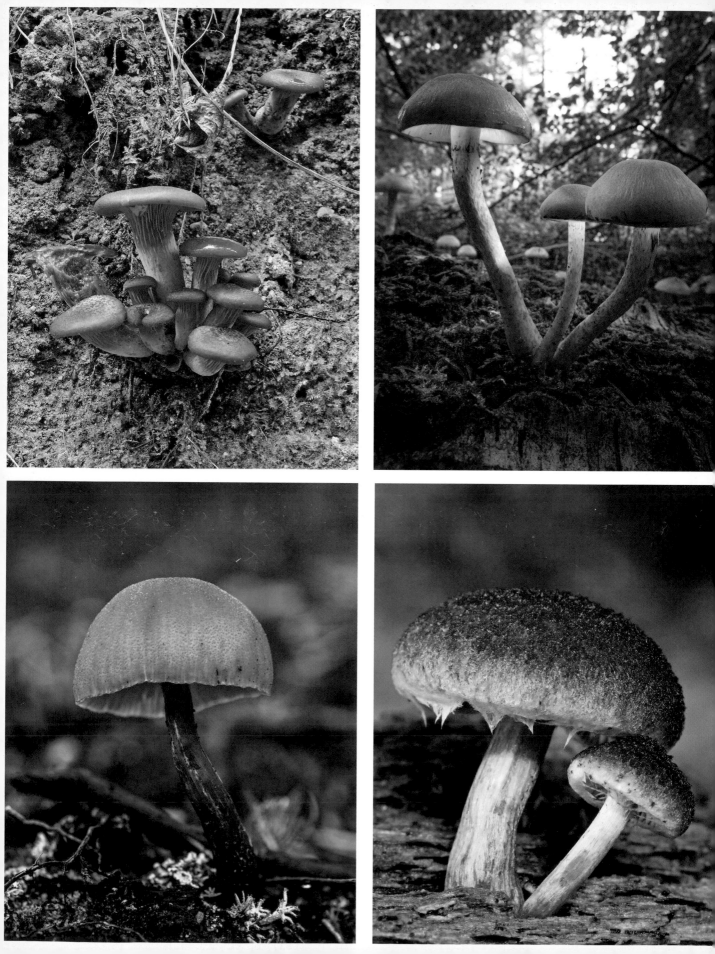

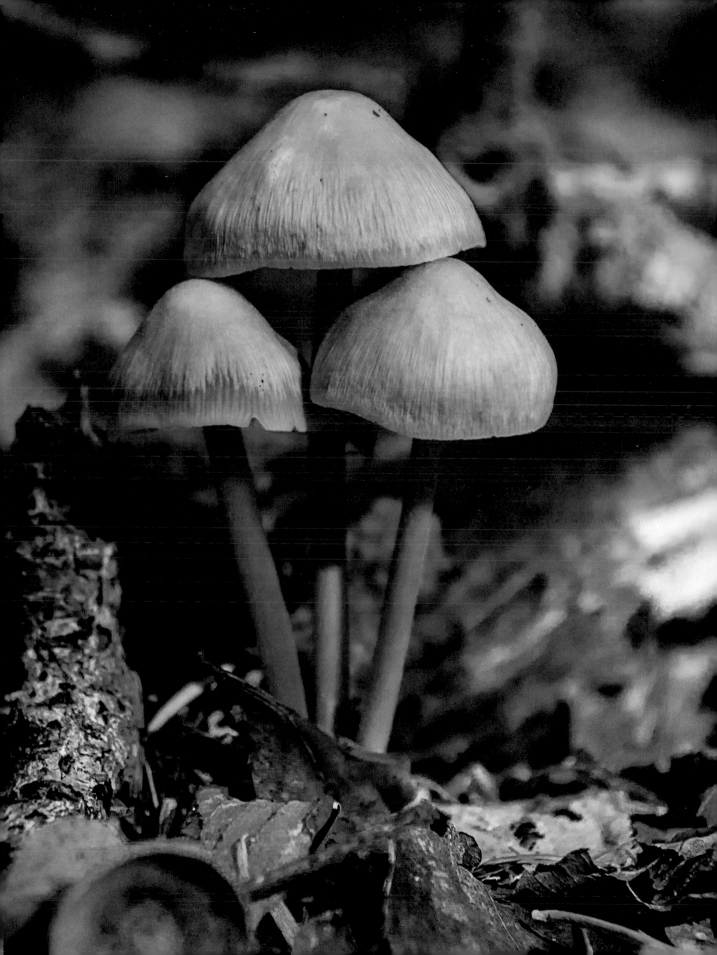

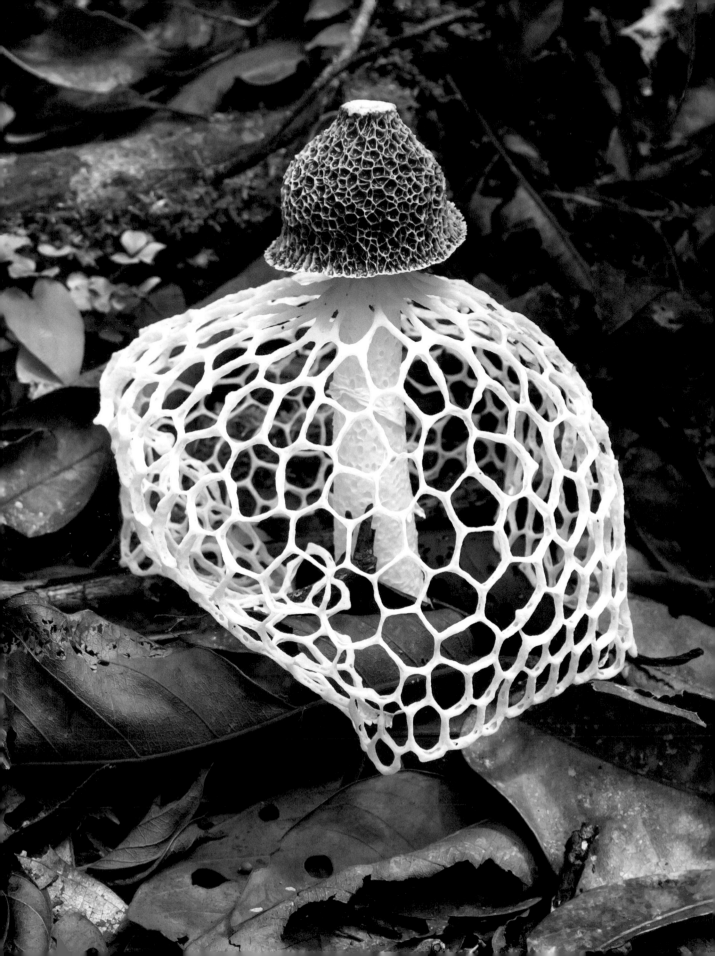

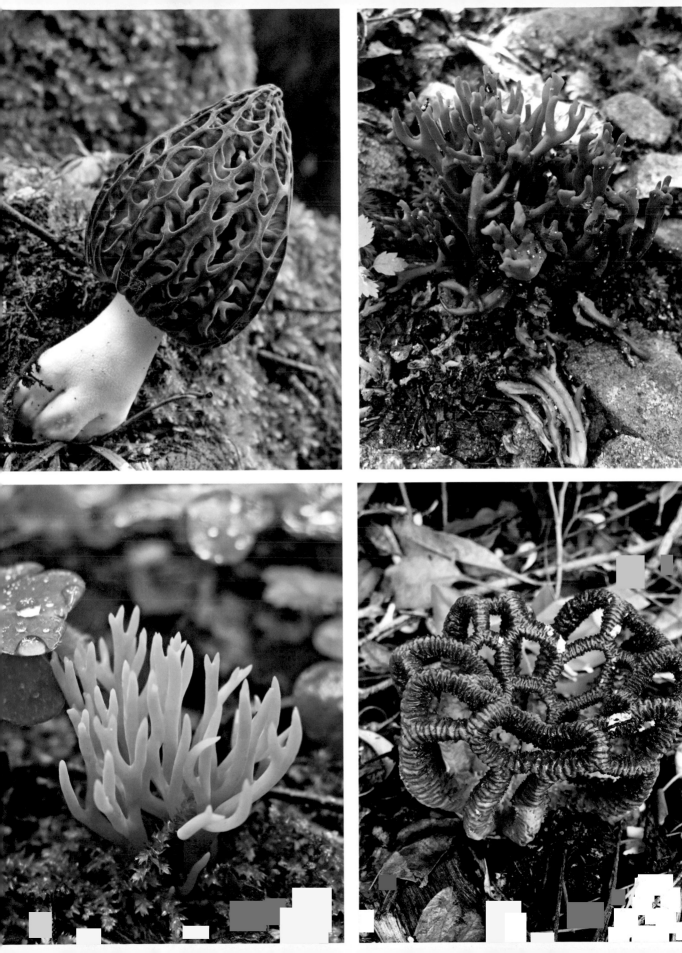

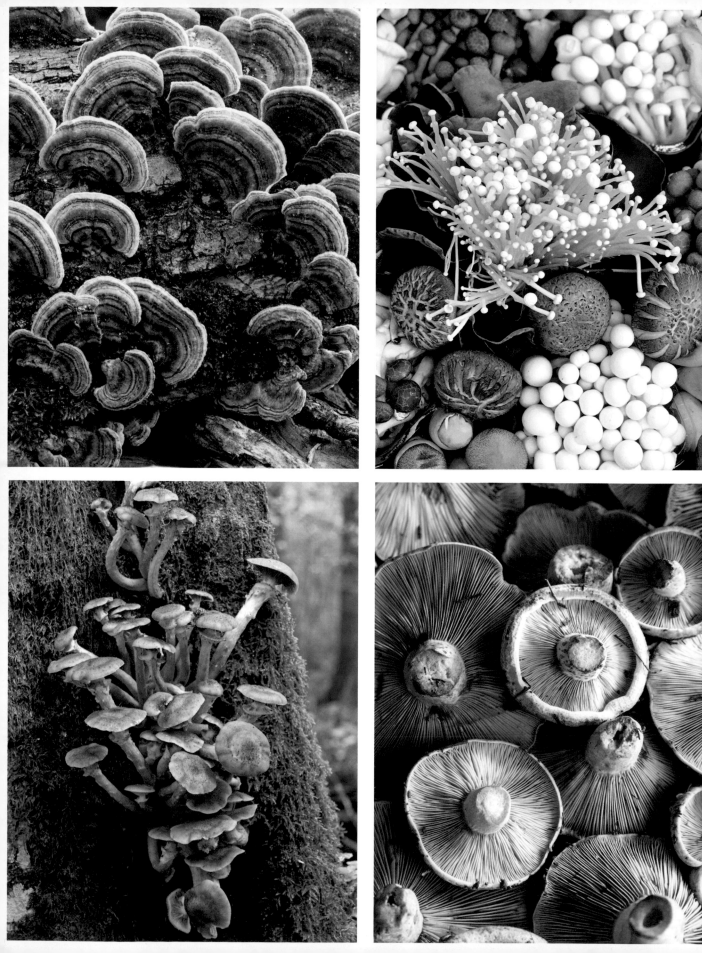

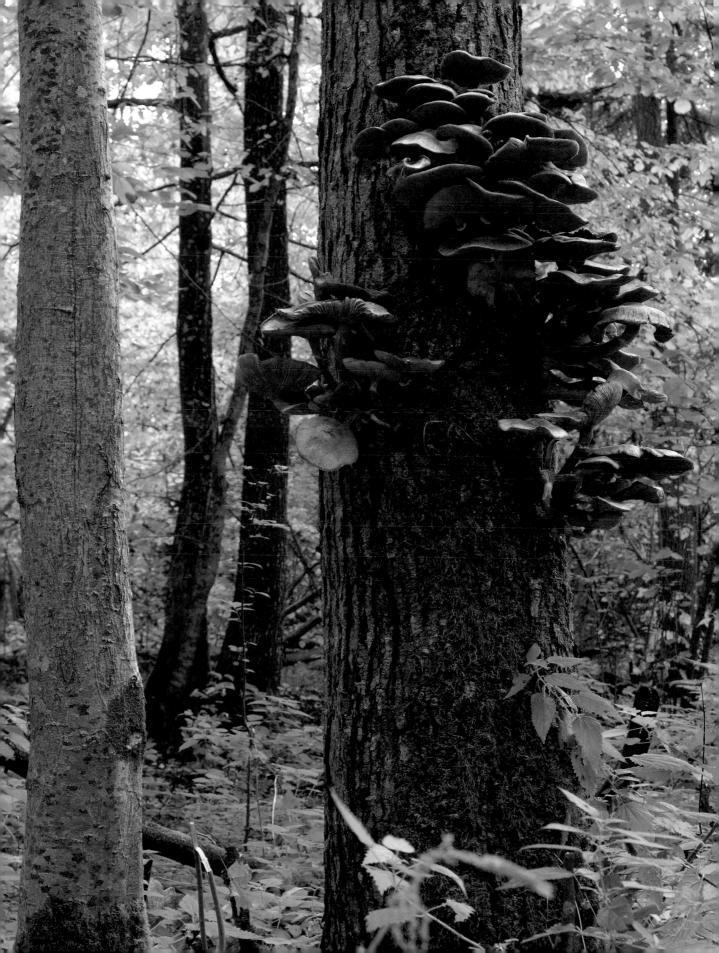

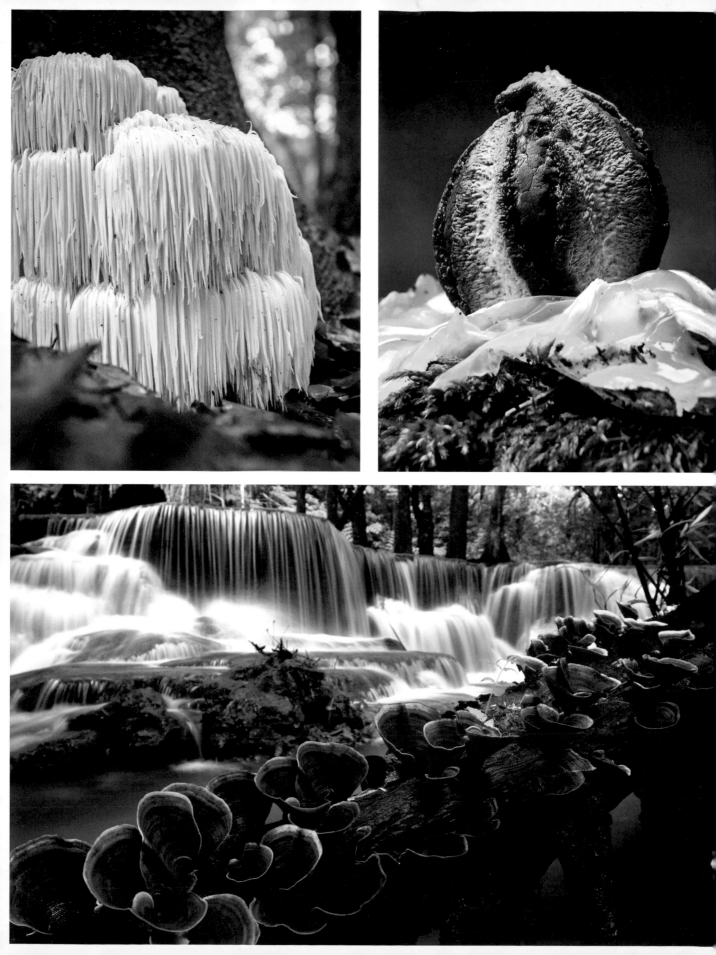